blank generation revisited the early days of punk rock

blank generation revisited the early days of punk rock

photographs by
roberta bayley,
stephanie chernikowski,
george du bose,
godlis,
bob gruen,
and ebet roberts

introduction by lenny kaye

foreword by glenn o'brien

SCHIRMER BOOKS
AN IMPRINT OF SIMON & SCHUSTER MACMILLAN
NEW YORK

PRENTICE HALL INTERNATIONAL
LONDON MEXICO CITY NEW DELHI SINGAPORE SYDNEY TORONTO

Copyright © 1997 by Roberta Bayley, Stephanie Chernikowski, George Du Bose, Godlis, Bob Gruen, Ebet Roberts
Foreword copyright © 1997 by Glenn O'Brien
Introduction copyright © 1997 by Lenny Kaye

Project coordinator: Stephanie Chernikowski

All rights reserved. No part of this book may be reproduced or transmitted in any form or by any means, electronic or mechanical, including photocopying, recording, or any information storage and retrieval system, without permission in writing from the Publisher.

Library of Congress Catalog Card Number: 96-33147

Printed in the United States of America

printing number
1 2 3 4 5 6 7 8 9 10

Design by Elizabeth Van Itallie

Library of Congress Cataloging-in-Publication Data

Blank generation revisited : the early days of punk rock / photographs
 by Roberta Bayley ... [et al.] ; introduction by Lenny Kaye.
 p. cm.
 ISBN 0-02-864652-5 (alk. paper)
 1. Punk rock music—Pictorial works. 2. Punk culture—Pictorial
works. 3. Rock musicians—Portraits. I. Bayley, Roberta.
ML3534.B598 1997
781.66—dc20 96-33147
 CIP
 MN

This paper meets the requirements of ANSI/NISO Z39.48-1992 (Permanence of Paper).

foreword
images of punk

Punk rock changed the world. It made it faster, louder, simpler, skinnier, smarter, and less full of bullshit. You could dance to it. You could fight to it. You could stay up all night to it. It was the perfect sound track for quitting your job, redecorating your apartment, thinking about pop art or group sex or robbing a drugstore.

It didn't need a light show, fireworks, a guitar solo, a concept, or even a clue. Punk was rock and roll starting over from scratch.

This is what it looked like.

Punk rock started in New York. It wasn't started by fashion designers, which may be why it still looks great. Later on punk happened in London (started by fashion designers) and got really famous and some of that was great too.

These are images of the people who made it happen. Some of them are alive and some of them aren't, some are still famous and some of them aren't. But back then they were all world famous.

The world was about seven miles long and two miles wide and it was created when it got dark and it ended when the sun came up. Other rockers have made a lot more money and sold a lot more records, but these ringleaders of the subconscious mind are the ones that made rock that was really art not arty, these are the ones that made fun a matter of life and death.

These photographers were co-conspirators with their subjects. They hung out together, drank together, fell down together, slept together, OD'd and got sober together, went to the top together, went down the drain together. They would do what it took to get the shot. Because most of these here camera users rocked as hard as these here guitar users. You can see it in their eyes.

Glenn O'Brien
New York City
January 1996

acknowledgments

The photographers would like to thank Liz Penta, Hilly Kristal, Suzanne Dechert, Butch Hancock, and Mike Crowley for giving the original Blank Generation Revisited show its birth and long life, and Richard Carlin, Paul Boger, Alicia Williamson, and Jane Andrassi for turning it into this book.

Roberta Bayley: thanks to John Holmstrom and Legs McNeil for creating a great forum for my photographs in *Punk* magazine. Thanks to all the people in my pictures for standing still and Ed Martin for making such beautiful prints.

Stephanie Chernikowski wants to thank the people in my photos for giving me great shots and my collaborators on the book for helping me keep this thing alive. Thanks to Dan Cordle for teaching me to swim and to Henry Rollins, Martha Hume, Joseph Mills, Sandy Chernikowski, Rob Patterson, John Pelosi, and Vi Burton for ongoing support.

George Du Bose would like to thank Lane Pederson, Jim Erwin, Tony Wright, Eric Boman, Michael Zilkha, Kathy Schenker, Jeffrey Kent Ayeroff, Michael Plen, Robert Hayes, Glenn O'Brien, Richard Kramer, Andy Warhol, Steve Mass, Hilly Kristal, Jim Fouratt, and Rudolf Pieper.

Godlis would like to thank Merv and Hilly at CBGB, John Holmstrom at *Punk* and Lenny Kaye at *Rock Scene*, Leica for my IIIf camera, Roberta Bayley for letting me in, and Eileen Godlis for helping me out.

Bob Gruen wants to thank all his punk friends from John Lennon to John Lydon, especially David Johanson and the whole crowd at CB's and Max's.

Ebet Roberts would like to thank the people in my photos—the people who helped make them possible—and most of all my family, my friends, and all who have guided and inspired my life.

introduction

we belong.

Fill in the blank. Rip it, tear it, shred and disfigure it and sew the pieces back together, Frankenstyle, preferably with safety pin and guitar string. Dress it in a haze of 6L6 tube feedback and slash of chord; layer it in leather, vinyl, spikes, and *yikes*! Re: -invent, -configure, -volt, -act to, -action.

Talkin' 'bout any generation, really. As in to generate, stake a claim, raise a flag, design a personality. It's not hard for a given era, once the original *i-*'maculate conception is sussed. All you need to play is the name game, not only for yourself—try Hell, Ramone, Sioux, Rotten—but an attached anti-amoebic movement, splicing rather than splitting, a small coterie of like-minded individuals who attach magnetically, drawn from whatever epicenter—N.Y.C.'s Bowery, to name the most volatile in my particular happenstance—they find themselves niched. Sign on the dotted line for a lifetime membership in a club that's hardly exclusive. Flash your blank more than once, hang out and hang in there, and dream up something that gives-and-lives with those with whom you share the scene. Clap along. Rush the stage. Take it or leave it, like the song says.

We've all been there, whether or not the flashbulbs are popping, keeping track of who was who and what they looked like. And walked like, and posed like, and leaned like, against the archetypal brick wall that contains a club wherein is performed the rock and roll called punk, or new wave (très Godard), or whatever. Music of the late seventies alter-native scene. After a while it got to be a thing, and that was how we played it. Thing music. Loud, fast, no-rules. At least until the next set of rules came along to expand, deny, argue with, co-opt, implement, overthrow, and ultimately start the next spin of the wheel.

Many—bands, solo artists, dabblers, fashion plates, dancers, filmmakers, actor-esses, runaways, suicidal maniacs, innocents caught up in a world

they were unprepared for, camp followers, heathens, naysayers, eyes for a buck, visionaries—added their idea, and in some cases, ideas, into the musical melting pot. This book has pictures of them. At work and play, as if there was any difference.

everybody has some kind

of scene, even if it's alone. The times of your time, or at least, one of your times; another day in the neighborhood. We live a succession of scenes, set in the geographic and the temporal, place and moment, and when enough time has passed, usually about two decades worth, they become vintage. Collectible.

The revealing snapshot. An instance held instant, bordered by setting, in that order. A rare portrait, we used to call it at *Rock Scene*, the photo magazine I helped edit in the seventies with Lisa and Richard Robinson, if only because that particular mingling of third and fourth dimensions on its way to becoming two could never happen again, so catch it while there's still a chance. Click the shutter; freeze and frame. You can look through my scrapbook anytime.

For generations, there's always the before and after, the family tree amidst forest. Still sprouting, hopefully, if not in deed, then influence; and of course, remembrance. The guardians of history are soon rewarded with history themselves; anon.

I met P. in a record store. She worked in a bookstore. We knew the traditions we were aligning ourselves with, where to put the needle in the fabric. It didn't necessarily mean that we had figured out how to do the cobra stitch, to extend those traditions beyond the point of tribute and homage. Still, there was no sense of goal beyond celebration, aside from the irrevocable one that goes hand in hand with rock mythos: anyone, anytime, can find the key. It helps if you're not sure what you're doing.

Haphazard, just like a scene itself grows, by improvising and jamming. Keep looking till you find the music you like to dance to. As more and more people start playing on the same tune, the song generates its own momentum and you just get caught up in it. Where to go; what night, with whom? The Big Bands are back, only this time you're in them, and they're playing your hometown.

Most of the time it's nothing more than a night down at the "local," as the English say. Sometimes that little scene you call your own catches fire, and your "local" becomes the world's, as the world becomes yours. All Mod Cons communication, global style, with a sound track to bootleg. Contra-band.

For me, it began on an Easter Sunday 1974 when, symbolism piling on symbolism, I left a screening of *Ladies and Gentlemen, the Rolling Stones* with P. to go to a Bowery bar that t-boned Bleecker Street to check out a band called Television.

At the time, it seemed like just another night of cruising around, mid-seventies Manhattan style, a club here, a loft there, Club 82, Max's K.C., the Nursery, looking for a parking space every afterhours A.M. until dawn cracked the eggs of your eyeballs over the city. Urbania.

The ——- generation was, if nothing else, citified. Turnabout is the way of scenes, differing them one from another in much the same way clubs rise in and out of favor, clothes change their shimmering fabrics, instruments their tone, and slang their metaphorics. If the sixties called for rural, bright colors, be-ins in the park, liquid light shows, freaking and fucking freely, the seventies went all chiaroscuro, b&w and grainy, tenement realism and salvation searched for in a perverse universe.

In other words, the Velvet Underground. Move the pointer from the West to the East Coast, throw in a grinding, garage ethic of simplistic noise coupled with droned desire, and notch the reactive toward virtues rock had once stood for, flying in the face of the legions of prog.

The waveform had taken a while to crest, carry-

ing with it vast footnotes of rock-crit theory should anyone involved care to have their obsessions rationalized. But beyond the sociology was the literal immediacy of the music, for those who made and exulted in it, and those who listened. There wasn't a lot of difference between the two, which made it accessible, something the increasingly professional sheen and hierarchy of the early seventies seemed to lack. A way in.

Without being too simplistic, that short step from wannabe to overnight sensation has been part of the rock dream from the moment of Elvis's (Presley to Costello) creation, obscuring the deceptively creative lust and high-rolling fervor needed to make music out of limited technical resources and learning-as-you-go. It takes a forgiving audience as well, one that likes to watch onstage struggle; and that's where the aspect of *scene* comes through, the shared organism of belief and value that lifts even the most amateur-hour performance into a work-in-progress.

All musics grow from the soft white underbelly of the reigning pop oligarchy. Rock as rebellion permutates into self-prophecy, an ante continually upped to continue outshocking itself, holding back any veneer of encrusting respectability. Flying in the face of flower power, bands like the Velvets, or the Detroit energy axis of the Stooges and the MC5, offered a vision considerably less pastoral than their hippie counterparts, though they had all begun in the same sixties era. "Black to Comm" heralded the Five's excursion into free jazz and white noise; "No Fun" announced Iggy of the Stooges' exquisite boredom. The Velvets counted down the concentric circles of hell in an attempt to catalogue every last sin and blasphemy, and then all three saved (or gaved) their lives by rock and roll.

These bands formed the trinity that would inspire

Lenny Kaye, Bowery, 1977. Photo by Godlis

a generation searching for its blank, though they were by no means the whole story. High Art vs. Low Trash was elevated into a common assumption: junk TV, junk couture, junkie business (too much). After years of rock "maturity" (operas, symphonique suites, concept albums), a return to basics was trumpeted, or rather, guitared. Far from being a dirty word, "pop" made a comeback. Rock could be Art (as opposed to "craft"), but that didn't mean it had to take on the trappings of moral responsibility. Actually, quite the opposite was true. Art-rat: the more contradictions the better.

In the early 1970s, the New York Dolls gathered a bunch of these stray-dog impulses, ladled on a dose of glitter and glam that was England's reaction to the au naturel sixties (see T. Rex, D. Bowie, and "All the Young Dudes"), praised the classic girl-groups and Brill Building trash (*pick it up!*) in general, and created a scene from where there had previously been none. Born in the basement of a bicycle shop on New York's West Side, cross-dressing genres at an out of the way venue called the Mercer Arts Center during a time when New York only hosted national touring combinations, they provided a focal point for the city's disaffected musicians, many of whom had only picked up an instrument months before.

By the time the Gilded Age had subsided, with the Dolls coming up short against middle-American resistance, their own inner time bomb, and *Star* magazine folding (not to mention Rodney Bingenheimer's L.A. glitter mecca), their floating crap game was cast adrift. For a while, it was just bands wandering between makeshift venues, folk clubs on W. 4th St., block parties, hotel restaurants, lofts.

One night a bottle blonde kid named Richard Lloyd asked me at Max's to come down and see his band. He called them Crossfire, and so I called him Crossfire. After a couple of months he was in another band, this one christened Television, with a guitarist named Tom Verlaine and a bass player, Richard Hell, who was friends with P., and even was at the rehearsal on Times Square when Richard Sohl walked into our practice room in a sailor suit to become DNV. At the same time, a lot of everybody else was walking into each other's rehearsal spaces, and coming down to see each other's shows at CBGB, usually on Sunday nights when Television or the Ramones played. There were the Stillettos. Suicide. The Miamis. We took turns being the audience, then a quick prance onstage, then back to the audience.

The bands weren't really alike. There was a self-awareness to their work that spoke of some knowledge of conceptual art—these weren't culturati babes-in-the-woods, despite Johnny's and Joey's and Dee Dee's and Tommy's matching leather jackets. Tom Verlaine once said that each grouping was like a separate idea, inhabitating their own world and reference points. Of them all, I loved watching Television grow the best; their virtuosity took such a long realization that when it finally arrived in the one recorded take of "Marquee Moon" on their debut album, it felt like it was a theme song to their ascendance.

Hell would leave Television long before that, joining forces with Johnny Thunders in the Heartbreakers before taking his theme song, "Blank Generation," to yet another group, the self-led Voidoids. The Stillettos bisected, with the blonde one, Debbie, going off to form a band named after her hair color. The Dead Boys moved from Cleveland to get in on the action; the Talking Heads showed up one day from the Rhode Island School of Design with a Bohannon record in their back pocket. The Ramones were probably the biggest misfits, reducing their repertoire to slogans and power chords, sure they were writing hit songs, when in reality, they were!

It was never just New York. The impulse was everywhere, pickpockets of malcontents sprouting

like extension cords, hidden like the mess of tangled wires behind your stereo. Making a bizarro trek to the west coast with P. and DNV in November 1974, playing audition nights at rock landmarks like the Whiskey and Fillmore, we were greeted with kids like Phast Phreddie and the *Back Door* crew in Bollywood; or Damita and Aaron and the Rather Ripped gang in the Bay Area. They encouraged by their very presence, enthusiasm, and support, rooting for the same bands we did, and that included the Rolling Stones. No rock snobbery here. We just wanted to get inside the music. I met John Cippolina backstage at the Fillmore; Jonathan Richman of the Modern Lovers played drums. I spent most of the set trying to get in tune. First things last.

Once, on some conversational roll, I sawed myself out on a limb when talking to *Melody Maker*; rambling about how tuning is the most irrelevant way to judge music if you can even judge music sonic energy can't be taught intuition out there cosmic spiel yadda-yadda. Then they invented handy pocket tuners. Next question.

Most everybody on these pages eventually figured out how to play their instrument; some, in fact, so well, that they have become classics of the era, Sounds of the Seventies, Sounds and Sights of the Eighties, History of Rock and Roll boxed version and CD-ROM. That's the beauty of capturing an instant, making it yours forever.

six photographers who

were there. Part of the scene, killing time between sets, sorting the contact sheets, making friends with the combo-nations that swept across stages worldwide. The time was ripe; the picture was there to be picked.

Who are these people, the ones framing the angles and the others in the frame? This isn't some anthropology mission; the photographers are propped against the wall of a dressing room, first-name basis, night after night, which is how everyone who comes within rangefinder doesn't feel like they're putting on a freak show, or even better, that they have the freedom to put on a show, unafraid to let themselves be who they're becoming.

There's a lot more Rise than Fall, fitting for camera eyes that sat around and had a drink before taking a photograph. They wanted to be there, would have been there if they didn't have to be there, or hadn't thought to pick up a lens and document the sights they were witnessing, and so we get to be on the Tri-X as well, light reflecting off the rain pavement: Bowery '76, London '77, L.A. '78, the world as the message spreads '79, '80, '81

The telling detail: the guitarist's middle-finger extended "rock and roll" chord on the left Gibson in Stephanie Chernikowski's "Sid Plays Max's," all the more real because that's how you really play it, neither major nor minor. Bob Gruen, given his late night roaming stance, well appreciating the ecstatic look on Stiv Bators's face when he realizes he's achieved a rock and roll dream befitting the New York Dolls logo on his t-shirt. Poly Styrene, up close and possessed, courtesy of Ebet Roberts. George Du Bose sets and shoots his portrait of Lydia Lunch as the Queen of Clubs. Godlis's summer No-Wave shot (soon to be Noh Wave), with a baby-faced James Chance and the vulcanized memory of Anya Phillips. Roberta Bayley, muse and confidant; the rose of the scene, with her still life of the Heartbreakers.

So it was that we came down to the same juke joints most nights in the weekdays, when the outer boroughs took their leave of Manhattan and the regulars poked blinking eyes out of daytime caves, creatures on the dark side of the rock moon.

As the scene spread, connecting its tentacles into an international network, you could walk into any club, concert hall, record shop, or clothing stall where your word had spread and they had a sound

system that played your hit parade—the many r's of reggae, raunch, and rockabilly—and find your people, some of whom you'd know from stopovers they'd made on your home stomping grounds. Everybody had bands, or were band fans, until the scene was so happening that it transcended the bands, and then it became a style, an easily identified category. Punk rock. A regular genre; a genre of regulars.

The inevitable hardening of the fashion arteries started when the scene moved across the Atlantic, to England. The mood had lain there in wait, along the King's Road where Malcolm McLaren brought back images of the Dolls and Richard Hell to foment his own version of upheaval, at the Roundhouse, down the Portobello Hotel bar. When the Sex Pistols went on Bill Grundy's BBC television slot and acted like, well, punks, the tabloids had a field day, and pretty soon a musical move-and-groove became a gen-yoo-wine youth cult, capable of outrage and allegiance. Mods, rockers, skinheads, rastas, punks. Definition.

The aborning sound acquired a look, and a code, and certain elements were strained from the mix-ages to write the rules of disorder. The Pogo, a vertical dance craze. Spitting on performers to show 'em you love 'em. Torn sleeves, bondage zips, pointy corners, and black on black. Eight downstrokes per measure. Take your heart off your sleeve and stick it to the front of your guitar. Paint the notes on the fretboard. Plug the fucker in. You ain't the first and you won't be the last. It was CB's and Max's in New York. The Mabuhay in S.F., Madame Wong's in L.A., the Rat in Boston, Bookie's in Detroit, the Longhorn in Dallas, the Roxy in London, the Gibus in Paris. Dozens more, at least one in each town, just like your basic shitkicker and blues and sports and biker's bar, where you could go, wear your colors, and shoot the breeze or just shut up.

The stages grew larger; record sales expanded from independent colored plastic seven-inchers to major label one-footers in shades of metallic gold and platinum. The cast of characters expanded; every conceivable kind of offshoot and variation came out of the shadows.

The momentum quickened; it was like everybody had figured out the direction and could make up for lost time, a straightaway after a series of hairpin turns. Keeping up to speed, there wasn't as much chance to look around at the scenery, take a turnoff, stay overnight in a town not on the map. Along with the the slight disappointment of knowing where you were heading was the potential thrill of trying to figure it all out from scratch again once you got there. On the Road, just like another generation that began with B.

I went to the Whitney recently to celebrate my birthday by seeing the Beat exhibition. I've always felt inspired by their generational example, honored to be in their poetic presence, landmarking the coffee shops and buddha dives and that perfect goatee-bongo drum-finger snap cliché that helped spread the message of freedom and liberation out to those who might never have crossed its path. Looking for the bohemian. Of course the beatnik was a cartoon, but so was punk, and this is a country that likes animation, even if it is sometimes suspended.

There's one candid displayed of Jack K. at a New Year's Eve party; it hangs down a corridor from the teletype roll on which he wrote *On the Road*, its grailness tucked in a plexiglass glass just outside the corner of his vision, as it must've been at that period in his life. He's passing through a New Year's Eve party in a loft downtown—it hardly matters what city. We've all been there, looking somewhat like him, distracted and dreaming.

Life sliced through six different unsquinting eyes, you won't only find the strangest, most visual, most outgoing, most talented people, in these photographs. I like to look for the passerby (*I want to destroy passerby* sang Johnny Rotten, his Sex Pistols a perfect self-immolation), standing in a

background, entering a room, in the audience, watching from the sidelines as the pageant unfolds, picking each other up and putting each other down and patting each other on the back, perhaps on their own way to motivating the scene.

Even the portraiture has this informal paparazzi quality, no Bruno of Hollywood perfections here, all instamatic onstage or emblazoned against an appropriate backdrop, clowning around or taking it seriously. Everybody has BYO to the party, and not everybody is a musician; there are those who drop by, on their way to films, books, romantic liaisons, dinner or a movie, the sex industry, drug dealing, brokerage houses, families, and normal lives.

Punk rock wasn't the only show in town in the lucky seventies and luckier eighties. A particularly glossy disco was having its fling, followed travolta-ly by urban cowboys; postliterate jazz and Glassine minimalism was avant-of-the-moment, and *Charlie's Angels* was on the Trinitron. After a while facing off with each other, like the final showdown in *The Good, the Bad, and the Ugly*, these equidistant musics started mixing their gene-ius pool.

Blondie got the beat ("Heart of Glass") and enshrined siren Debbie Harry's image in every radio and video flashdance. The Clash clash-ified any music they came across, from the rawest tower-block sound of their garageland beginnings to the rock-punk vox popular of "London Calling" and "Should I Stay or Should I Go," winding up at Shea Stadium (though not as headliners. That rite of passage was saved for the Police). The Talking Heads took their dance rhythms and wedged them under a jittery, intelligent world-pop that spanned continents. The Cars provided as good a starting-gate for New Wave as any, with a raised eyebrow grasp of chorus and hook, sinuous synth and power pop guitar, kicking off "underground" music's reabsorption into the All-American Top 40, along with . . . the Knack? The B-52's were fun to party to, No Wave in the form of Arto Lindsay's DNA and the angular Contortions staked out the extremities once more, rock discos became more than an oxymoron, and finally there was "White Wedding" and the Cult. But that's another couple of scenarios away, and at this vantage point in the mid-nineties, we don't even have a catchy name for such recent history.

For the Punk-New Wave Era, the list is still endless—please look at the contents for a greatest hits selection—and will be even more so when the great archeological digs of the P/NW era start to take place, any minute now. I personally can't wait till the weirder nuggets come out of their hiding places in some strange punkoid parallel universe in Iowa, hailing the spirit of More New Bands.

I've been in a few MNBs myself, and actually join a couple more every time I go out. I'm glad to have the souvenir yearbook. Like any twenty-year reunion, the weatherings I see on my contempos' oversouls have come hard fought, revealing similarities that went hand-in-glove with our manic desire to harness the electric storm that first brought us together, when we invented what we believed in.

it's going to be a long

time before I get the distance to look at these shades—ghosts and friends and acquaintances and people you read about and sometimes got to meet—without the acute sense of having walked among them. Maybe you need a couple more generations between you and who you once are to really figure out what happened. Now you're still surprised; to have been there in the first place, present and accounted for, and to have outlived it.

There are those who didn't. Rack that artistically dissolute life, like your role models, excess and success, and the eight-ball casualties mount up. Death by misadventure, usually, or unfocused violence, or internal microbe, paying the skid-row price for falling over the edge, extreme-skiing the free fall of a mountain. Like any thrill sport, there are the

unforeseens: oil on the track, gearbox failure at valve float, someone else's accident you can't avoid.

Others manage to keep on staying out late, or go home early, and that's your lifeline on the scene. You know you're still around whenever you find yourself hanging by the bar one night at 3 A.M., waiting for some band to go on and listening to the d.j. spinning great records from forty-odd years of rock and roll, one-hit wonders to the greats, and thinking you'd rather not be anywhere else.

For a music with such burn-out intensity, the rock impulse seems to need to reshuffle its cards every four or five years, like periodic meteor showers, which I think of as a generation, enough time to gather music for a B-side discography and make way for the next onslaught of eagerness. A chosen few dig deep enough into the common psyche that they maintain momentum from scene to scene, like someone hopping across a stream on a path of submerged stones, or a time trials rider picking a precariously balanced path over a mountainous course. Sometimes you comeback and sometimes you don't go away. Then there's that other Re. Vival.

Everyone should have at least one, if only to let us know that enough generation has passed for there to be another. Maybe two, three. Who's counting? It's more like when the tail of the crack-the-whip flicks back and snaps at you, curling around like a vortex, and you can feel the wind whistle past, catching you in its wake.

Why, then and now. Why this particular response to rock was picked out to be jet streamlined; why you got picked up along with it; why you're picking up this handheld cinematheque of stills instead of one devoted to some other scenery.

I know the reason I'm here. Let the Ramones count it down: *one two tree faw*, and the Dictators two-tub it up and the Damned kick into "New Rose" and the Jam blast "In the City" while the Police back Cherry Vanilla and Generation X lead singer Billy Idol (rhymes with Marty Wilde) gets his hair cut in a crew Chicago Box and the Slits start rub-a-dubbing reggae and the Cramps punkabilly out and along comes the Avengers and Crime and the Zeroes and the Zippers and the Viletones and Sham 69 and the Damned and the Brats and Stinky Toys and Wayne County and the Buzzcocks and Wire and Willie Alexander and the Wipers and the Sods and Chelsea and Mong and the Rude Kids and the Runaways and Black Flag and Pere Ubu and Tuff Darts and the Shirts and Mink De Ville and Skafish and the Stranglers and the Germs and the Dead Kennedys and X and the Lurkers and the Adverts and the Sic Fucks and the Circle Jerks and MDC and the Motor City Bad Boys and the Dils and the Nuns and Penetration and Eater and And.

We're all in this together.

Lenny Kaye
January 1996

roberta bayley

I grew up in the San Francisco Bay Area and came to New York City in the spring of 1974. I had been living in London for two years. New York seemed very alive after that. The city was bankrupt, rents were cheap, and poverty fueled the imagination. Originality flooded the streets. On the music scene, glitter and glam were fading. Everyone was looking for something, the next thing. To be it or see it. And then, suddenly, there it was. In January of 1975, Television's manager, Terry Ork, asked me to work the door at CBGB on the Sunday nights when the band played. That became my job for the next few years, as more and more bands came to play. In November of 1975 I bought a Pentax Spotmatic and began taking pictures of the different bands. I went to work for John Holmstrom and Legs McNeil at *Punk* magazine and learned the true meaning of creative insanity. The Ramones used one of my photos for their first album, and so did Richard Hell and Johnny Thunders's Heartbreakers.

I went to England and photographed the punk scene there. I worked for Blondie for a year in guerrilla warfare. I toured with the Sex Pistols across America recording the end as we know it. I shot *fumetti*s for *Punk* and crossed America with Richard Hell in a 1959 Cadillac. By 1980 everything had changed. I'd pretty much photographed everyone I had ever wanted to photograph who was still alive, and I was in serious danger of losing my status as an amateur. I put away my camera and disappeared. These photographs are my record, the evidence of what was.

The Heartbreakers session in 1975 was my first. The photo was to be captioned "Catch Them W

ey're Still Alive." The idea for the photo was Richard Hell's. The "blood" was Hershey's chocolate syrup.

Tom Verlaine had an idea for a black & white poster of Television so we did some shots in their manager's loft in Chinatown in 1976.

The Voidoids were Richard Hell's band after he left the Heartbreakers. Richard knew Robert Quine from when they worked together at a film bookstore called Cinemabilia. I shot Quine, Hell, Ivan Julian, and Marc Bell in Richard's apartment in 1977.

Session for the Ramones' first album cover was originally shot for *Punk* magazine in 1976. The band didn't like the photos taken of them by the "professional" photographer Sire had hired but they had blown their photo budget. I was paid $125.

The Dead Boys came from Cleveland to play CBGB in 1976. They still had long hair and flared jeans. By their next visit they'd all gotten haircuts.

Richard Hell exudes punk sexuality in 1976.
This shot was used on the sleeve of the British single of "Blank Generation" on Stiff Records.

Legs McNeil and I were walking over to the Factory on Fourteenth Street to interview Andy Warhol for *Punk*.
On the way we ran into Richard Hell so he came along. Andy later appeared in *Punk* as a mad scientist in "Mutant Monster Beach Party."

Joey Ramone surveys the surf at Coney Island for the "Mutant Monster Beach Party" issue of *Punk*.

Deborah Harry and Chris Stein in the back of their limo on the way to a Blondie gig in Asbury Park in 1979.

Joey Ramone and Debbie Harry pose for *Punk* magazine's *fumetti* "Mutant Monster Beach Party" in 1977.

Talking Heads were still a trio when they were filmed for a local TV show on punk rock.

(left) The Sex Pistols at Cain's Ballroom in Tulsa, Oklahoma, in January 1978.

(right) Sid Vicious before sound check at a club in Baton Rouge, Louisiana, on the Sex Pistols' American tour. His button reads: "I'm a Mess."

Billy Idol on the New York streets after the breakup of Generation X in 1978.

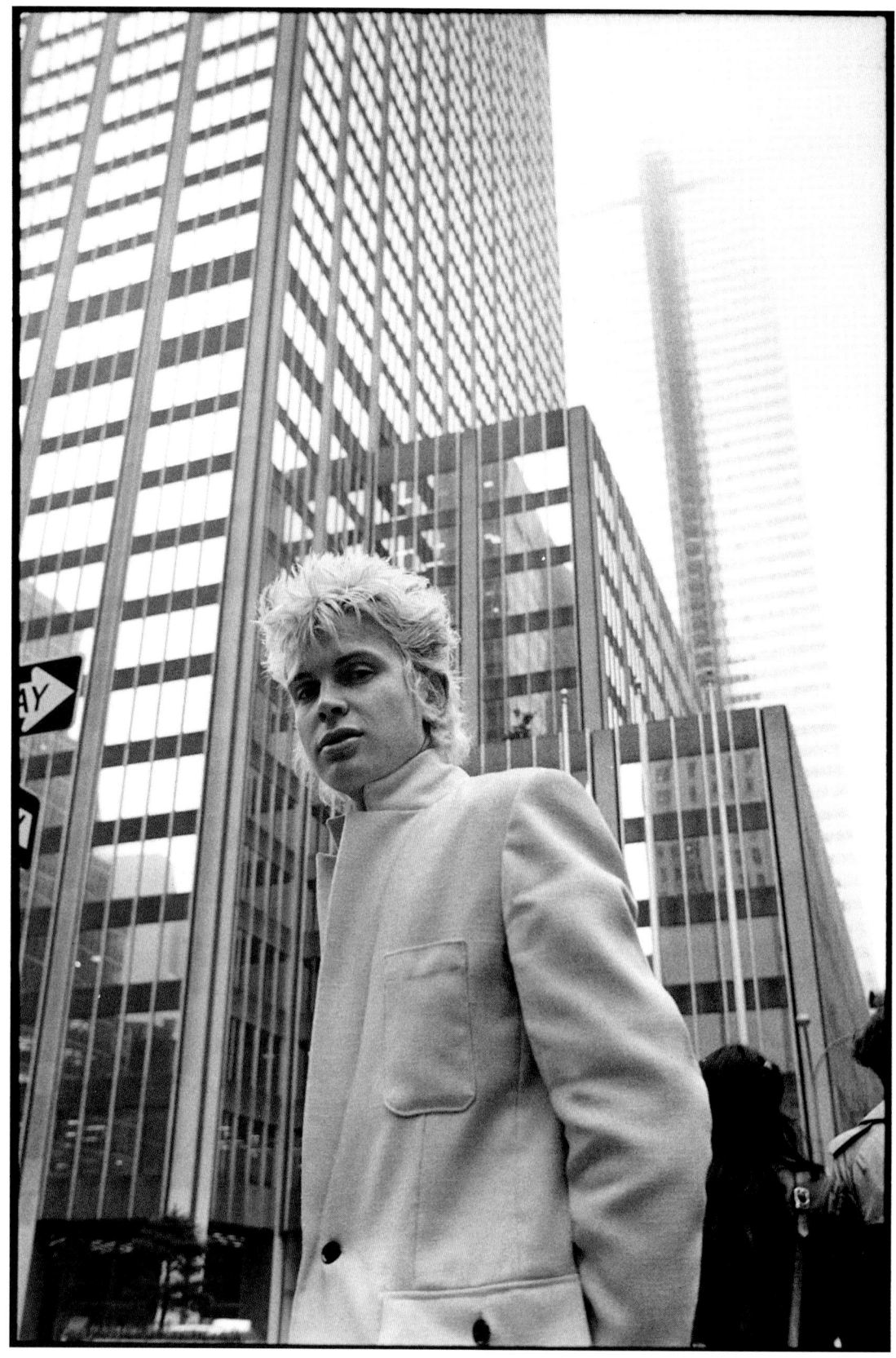

The Damned were the first British punk band to play CBGB. This shot was for the cover of a British daily.

The New York Dolls together for the first time since their 1975 breakup in front of Gem Spa, a newsstand on St. Marks Place where they were photographed in 1972 for the back cover of their debut album.

David Johansen on the New York subway in 1978.

Elvis Costello backstage at CBGB in 1978.
The color version of this shot was used as a publicity poster for *Armed Forces*.

Elvis Costello and Richard Hell onstage with the Voidoids at a benefit at CBGB.
They performed "Shattered" by the Rolling Stones.

Joe Strummer on New York's Lower
East Side in 1980.

stephanie chernikowski

decisive moments
born and reared in east texas bayou country
kissed by elvis as a teen
my rock & roll fate was sealed
first used a 35mm camera the day of the first moonwalk
I always liked to look
moved to macdougal street nyc 10.75
saw nureyev dance and heard patti and lenny do piss factory
first assignment for the village voice: alex chilton 2.22.77
walked in cold off the street, didn't know a soul, and never showed a "book"
call me lucky
east village streets ragged and still at dawn
last night's guitar roar humming in my ears

David Byrne, NYC, c. 1982.
At my studio in available winter light. He waived the photo approval
demanded by his publicist. Music: the Neville Brothers.

Tom Verlaine, NYC, c. 1978.
At the Record Plant during the sessions
for *Adventure*, Television's second album.

Joey Ramone, NYC, c. 1979.
At Arturo Vega's loft (Joey had previously lived there). Alan Arkush, who directed *Rock and Roll High School*, handed Joey the buck.

Patti Smith, NYC.
Our Lady of the Bowery in an unadvertised performance at CBGB.

The Ramones, Brooklyn, c. 1979. Johnny, Marky, & Dee Dee during sound check at a club in Brooklyn. As we drove up to the club later that night for their show, Johnny commented on the tough-looking kids. They were all dressed like the teenage Ramones.

Alex Chilton, NYC, 12.4.84.
A master of anarchy, shot at my studio. I ripped and spray-painted
the seamless paper. Burns added by the Replacements.

Richard Hell, NYC, c. 1980.
Aka Tryptic in Shards. Shot for a "Homes of the Stars" photo essay for the *New York Rocker* inspired by a trip to Nashville. Music: Al Green.

Iggy Pop, NYC.
At the Palladium during his vintage solo years. Age cannot wither, nor custom stale him. Iggy rocks.

John Lurie, NYC, date unknown.
Shot in the ladies/men's room at the Mudd Club. Saxman for the
Lounge Lizards and star of Jim Jarmusch's *Stranger Than Paradise*
and *Down by Law*.

Debbie Harry, NYC, 1978. The face that launched a thousand photographs, at CBGB during the Blitz Benefit, which was held to pay hospital bills when Dead Boy Johnny Blitz was stabbed. Punk's Woodstock, maybe.

Suicide, NYC, date unknown.
Alan Vega and Marty Rev at my
studio on the Bowery.

The Cramps, NYC, 1979.
On a burned-out pier on the Hudson
by available light.

Lou Reed, NYC, c. 1979.
At the Bottom Line. Andy Warhol was in
the audience.

Ivy Rorshach, NYC, c. 1978.
The Cramps at the Palladium on Halloween. She didn't sing. She didn't smile. She played guitar. She was fierce. Still is.

Ian Dury, NYC, date unknown.
On the roof of the Gramercy Park, a hotel frequented by visiting musicians.

Graham Parker, NYC, 1977.
Shot on the roof of the Gramercy the morning after Rod
Stewart's aftershow party at Regine's, a chic midtown disco.
The contrast was as profound as the hangover.

Sid Vicious, NYC, c. 1978
Performing more or less live at Max's
Kansas City backed by former NY Dolls
Syl Sylvain, Arthur Kane, and Jerry
Nolan, as well as Mick Jones of the
Clash. Nancy Spungeon watches from
the side of the stage.

John Lydon, NYC, c. 1978
With Public Image Ltd. at the Great Gildersleeve's on the Bowery.
Little Johnny Cool chanting doom to a bebop backup.

Richard Lloyd, NYC, date unknown.
Shot afterhours at CBGB. I ha[d] been to the Mudd Club and lo[st] my keys. The people at CB's l[et] me hang out till morning and Richard kept me amused.

Top Ten, NYC, 1978.
Scott Kempner of the Dictators behind CBGB
after performing at the Blitz Benefit.

george du bose

Alexander was a great punk. Genghis Khan, Attila, Henry the Eighth, Napoleon, Mozart, Elvis were all punks of their time. My grandfather told me that "a punk is camel shit on a stick that is used to light fireworks."

Punk is more than an attitude, it is a philosophy. One cannot become a punk by design. Punks are born, not made. You cannot call yourself a punk, it is a impression you leave with somebody else. Calling someone else a punk used to be derogatory or inflammatory. It has become a term of respect for an independent, anarchistic lifestyle roughly associated with a musical style and peripheral lifestyle.

My first exposure to "punk rock" was in 1976. I went to CBGB and saw the band Television. I had no expectations, but I paid my $3 and saw the guitar player playing worse than I would. I had foregone dreams of being a professional guitar player and could not fathom why this guitar player was making such a public attempt to be bad. So bad that I asked for my money back.

I had never heard of punk rock. I soon learned that even accomplished musicians were unlearning their techniques, stripping songs to the bone. Punk gave rise to the concept that serious musical study was unnecessary, even undesirable. Primitive, raw, and minimal music, vocals as an instrument, obscured lyrics—all that mattered was the power and emotion.

I saw Teenage Jesus and the Jerks open for the B-52's at Max's Kansas City. I heard Lydia complaining to her band offstage that one of the songs was too long at 45 seconds and said song needed to be 30 seconds. I began to understand, Lydia's band was trying to play poorly, the B-52's were playing as well as they could.

I hated Teenage Jesus, loved the Bs, photographed both of their debut album covers. Go ~~fuck yourself~~ figure.

Klaus Nomi, NYC, 1978.
A classically trained German opera singer, who performed original and cover material and a very moving aria. He was also a world-class pastry chef. This was his debut U.S. performance and probably the only performance with a live band. Max's Kansas City.

Suicide, NYC, 1980.
Alan Vega (vocals) Marty Rev (keyboards) performing at the Eighties (short-lived Upper East Side rock club). Alan had thrown the microphone into the audience at the front of the stage and someone threw it back at him.

Captain Sensible, NYC, 1982.
Formerly of The Damned, emulating the behavior
of one of his rock heroes, Keith Moon.

John Lurie, Brooklyn, 1989.
Leader of the Lounge Lizards.

The Fleshtones, NYC, 1984.
Publicity still from the *Hexbreaker* album.

Chris Spedding, NYC, 1980.
World's premier session guitarist at Max's. The drummer's name was Bob Wire. This is a distressed print.

The Buzzcocks, NYC, 1980.
In the basement of the Hotel Diplomat.

Ritchie Stotts, Queens, NY, 1986.
Former lead guitarist with the
Plasmatics photographed in the
world's largest cemetery.

Psychedelic Furs, NYC, 1982.
Richard and Tim Butler with their lighting technician. They were so excited to be posing for *Interview* magazine.

Diego Cortez and Victor Bokris, NYC, 1978.
Cortez, curator of the famous PS1 art show, and author Bokris
scuffling at a party at Maripol's loft. Victor is the only person I've
ever met who has a dueling scar from a champagne glass.

Dee Dee King (Ramone),
NYC, 1989.
Publicity photo for his
solo project after his
midlife crisis when he left
the Ramones.

Tom Waits, NYC, 1983.
"In Tom's Square." Once a punk, always a punk.

Glenn O'Brien, NYC, 1979.
Writer "boning up" for the opening-night performance by the B-52's at Le Club Mudd.

Tina L'Hotsky, NYC, 1982.
Self-proclaimed Queen of the Mudd Club, and author of "Crazy
Spanish Girls" attended by Phillippe, a French DJ.

Walter Steding, NYC, 1980.
At Trax, an Upper West Side rock club, with his bio-rhythm-controlled violin and glasses with blinking lights. Walter Steding and the Dragon People had two LPs produced by Andy Warhol.

Unidentified punk babe, fronting The Breakfast Club at US Blues in Roslyn, NY, 1980.

B-52's, NYC, 1979.
The original black and white image was retouched and hand-colored by Tony Wright for the cover of the first B-52's LP. This was a self-published poster with Japanese text at the top that I used to snipe before the B's shows in Manhattan. The posters disappeared so quickly that I began to sell them for 52 cents or two for $1.

The B-52's, NYC, 1978.
The first internationally published picture of the group. Cindy Wilson had gone home to Athens, Georgia, and Maureen McLaughin, their original manager, stood in for her. Picture was first published in *Interview*'s "Beat" music column written by Glenn O'Brien, then published in *Studio Voice* in Japan.

Lydia Lunch, NYC, 1980.
Publicity still from *The Queen of Siam* album.

Lene Lovich, NYC, 1984.
At the uptown Ritz (previously Studio 54). I had been standing in front of the stage from sound check through the performance. She knew I was anticipating a good shot—a kick and a wink.

godlis

I came to New York in 1976 looking for work in photography. I'd finished photo school in Boston, and answered phone calls in the complaint department of Fotomat. In New York I landed a job for a guy who did catalogue work by day, and prostitutes' portfolios by night. I spent most of my day photographing bank gifts and educational toys. I worked on the Valium and Crazy Glue accounts. I was in desperate need of entertainment.

One winter night I stumbled into CBGB to see Television. I knew nothing about the band or the place. It wasn't very crowded—in those days you could fit everyone who went to the place in one or two subway cars. But it didn't take a genius to figure out that this was the most interesting thing happening in New York City in 1976. The right people were attracted like flies, the wrong people didn't want anything to do with the dump. The next trick was how to photograph the place.

I made it my business not to use a flash. I pushed the film like crazy so I could shoot under streetlights on the Bowery while everyone was hanging out between sets. In between beers and conversation, I used a Leica 35mm camera with long, handheld exposures. I wanted to set down on grainy film what occurred in this particular place at this particular time. I was influenced by everyone from Diane Arbus to Weegee, from Brassai to Walker Evans.

I went back to CBGB every night for the next three years. When I graduated, I was a "rock photographer." These are the fruits of my labors.

Patti Smith,
Bowery, 1976.
Outside CBGB.
Quarter-second
exposure. Lit up
by streetlights.

Dictators, Bowery, 1976. Handsome Dick of the Dictators and girlfriend Jody the night he returned my lost wallet. I thanked him by doing this picture. No money was missing.

Getting a Punk
Haircut...

...With a Cigarette Lighter, 1977. Howie Pyro (pre–D-Generation) and Nick Berlin setting X-Sessive's hair on fire in the doorway of the Palace Hotel, next door to CBGB. There were no punk barbershops back then.

Ramones, CBGB, 1977.
The kids are all hopped
up and ready to go. View
from sidestage CBGB.

Talking Heads live at CBGB, 1977.
Their first performances at CBGB as a foursome. Spring of 1977, around the time they began recording their first album. Just before their first European tour that summer with the Ramones.

Divine and the Dead Boys, CBGB, 1978.
Benefit show for Dead Boys drummer Johnny Blitz.

Television, corner of St. Marks Place and
First Avenue, NYC, 1977.
Photo session for their second album.
Never used.

Sylvia and Anya, Bowery, 1976.
Sylvia Morales and Anya Phillips outside CBGB. Sylvia later married Lou Reed. Anya died in 1981.

Richard Lloyd, Hospital, 1977.
Photo session at Beth Israel Hospital in New York City, where Richard was recuperating, to explain the delay in the release of the second Television LP. The concept was Terry Ork's.

John Lydon, Warwick Hotel, NYC, 1979.
The paintings on the wall were crooked when I arrived. Lydon, hungover, spitting beer on the rug, never moved from that spot the whole session. In town promoting Public Image. This was the hotel where Elvis stayed before a 1956 TV appearance on the Dorsey Show.

Arto Lindsay, Bowery, 1978.
No Wave New York lit up by streetlights in the rain.
I think he was still in DNA at the time.

Bowery, Summer, 1978. No Wave Scene punks on car, outside CBGB. L. to r.: Harold, Kristian Hoffman, Diego Cortez, Anya Phillips, Lydia Lunch, James Chance, Jim Sclavunos, Bradley Field, and Liz Seidman.

Alex Chilton, Bowery, 1977. Single sleeve for "Bangkok." On the median strip of the Bowery. A raindrop landed on the camera lens, quite by accident. With swirling ambulance lights in the background, this was definitely a lucky night.

(left) Christopher Parker, Bowery, 1977. Richard Hell's "Kid With the Replaceable Head," star of Jim Jarmusch's *Permanent Vacation*. Outside CBGB.

(opposite) Richard Hell, CBGB, 1978. Singing "All the Way."

Stiv Bators, CBGB Kitchen, 1977. Yes, CBGB had a kitchen. No, I never ate there.

Klaus Nomi, Christopher Parker, Jim Jarmusch, Bowery, 1978.
Outside CBGB. Jarmusch was still in film school. Parker was starring in his first film. Nomi just appeared out of nowhere.

Cramps, Bowery, 1977.
Photo session by streetlights.

CBGB interior at Closing Time, 4 A.M., 1977. Stopped to take this picture as I stumbled out the door. Not too much has changed.

bob gruen

When I was growing up most of my friends were musicians and artists. Photography was my hobby and I have carried a camera since I was 13.

I do not have preconceived ideas about what I am going to photograph. I like a natural setting and I let people move on their own without much instruction from me. Primarily, I like to show interesting people as they are and I like rock and roll.

In the early '70s, I became friendly with the roving pack of journalists who were defining New York's developing musical society: Richard and Lisa Robinson, Lillian Roxon, Lenny Kaye, Danny Fields, and a cast of characters in the back room at Max's Kansas City. The Robinsons edited a magazine called *Rock Scene* and I became their chief photographer. I really enjoy going out day and night looking for lively people and places. *Rock Scene* gave me a reason to photograph the whole "scene," from front to back. I've made a lot of friends and had a lot of fun.

Television, NYC, 1974.
Richard Hell first sang "Blank Generation" when he was a member of Television. This was the first time I saw them perform at CBGB. The stage was in the middle of the room at the end of the bar. Along with Patti Smith, they were the first to play at CBGB. R. to l.: Hell, Billy Ficca, Richard Lloyd, Tom Verlaine.

The Runaways, Roslyn, NY, 1976.
The Runaways were a big sensation—five very young attractive girls who could play great rock and roll. This photo was taken the night they arrived in New York and played at My Father's Place in August of 1976. L. to r.: Lita Ford, Joan Jett, Cherrie Currie, Jackie Fox, Sandy West.

Wayne County, NYC, 1974.
Wayne County dressed like a woman and did very raunchy, sexy shows. His big song was "If You Don't Want to Fuck Me, Baby Fuck Off." This show was at the Club 82 on East Fourth Street in October of 1974.

Iggy and Debbie.
Blondie was opening a tour for Iggy Pop. David Bowie was Iggy's piano player. Before the first show in March 1977 in Toronto, I took this photo of Debbie and Iggy in the dressing room.

Outside CBGB, 1977.
Earl McGrath, Rolling Stones Records president, kids around with Ramones manager Danny Fields flanked by David Johansen on left and Joey Ramone on right (with Ramones lighting director Arturo Vega). Far right is Jimmy Destry of Blondie. It is a fairly typical view of CBGB.

Patti Smith and friends, NYC, December 1976.
After Patti Smith's show at the Ocean Club in Tribeca.
L. to r.: David Johansen Lenny Kaye, Dee Dee Ramone,
Patti, Jay Dee Daugherty, Tom Verlaine, and John Cale
gathered in the basement.

The Stillettos, NYC, 1974.
Chris Stein and Debbie Harry perform with the Stillettos at the Blue Angel in midtown NYC 1974. This may have been the first time I saw them. They opened for the NY Dolls, and sang backup during their set. Fred Smith, who later joined Television, is on bass. L. to r.: Stein, Harry, Elda Gentile, Rosie Ross, Smith.

Stiv Bators, May 1978. Stiv Bators and the Dead Boys were playing at CBGB and had some special guests appear with them. Stiv poses backstage in the old kitchen/dressing room with two of his friends.

Richard Hell and Johnny Thunders, August 1978. Richard Hell looks at Johnny Thunders's arm upstairs in the office at Max's. These two guys knew a lot about their arms. Johnny is wearing sleeves on his forearms to hide his tracks. Actually, Johnny is showing Richard his new tattoo.

Max's Awning, 1980.
The best time to be at Max's was around closing when everyone was on the sidewalk making a last effort to pick someone up. On the left David Johansen is impressing some girls.

Debbie Harry, July 1976.
Debbie Harry at the start of her rise to fame performing with Blondie at Max's.

Joe Strummer, 1981.
The Clash were in New York in spring '81 to play shows at Bond's on Broadway. Don Letts was filming scenes around town. I drove them to Battery Park in my '54 Buick to film Joe Strummer with the Statue of Liberty in the background. While they were setting up, Joe relaxed by kissing his girlfriend on the back of the car.
A classic rock and roll moment.

The Clash with the Gruenmobile (Bob Gruen's '54 Buick), 1978.
After their recording session at the Record Plant we took photos around the city and came back to my loft. The guys cooked some spaghetti they had picked up and I showed them the videos I had made of the New York Dolls.

Sex Pistols, November, 1977.
On the way to do an interview with
Radio Luxembourg near Brussels, the
Sex Pistols stopped at a bar where we
took this famous photo.

Sylvain Sylvain, January, 1977.
After the NY Dolls broke up, Sylvain had a band he called The Criminals. This is a publicity shot we made for him using his girlfriend, Linda Chase. It was the coldest day of the year, below zero in the Union Square station.

New York Dolls, 1973.
The NY Dolls were easy to photograph because they loved to pose and did it well. We took this photo at my studio on West 29th Street. I like the decadence of David's Pernod bottle and white tails suit, but for years I wouldn't use this photo because of Johnny's swastika. My seamless paper was old and had a crease so I crumpled it up to make it all wrinkled. Now it is a style. L. to r.: Arthur Kane, Syl Sylvain, David Johansen, Jerry Nolan, Johnny Thunders.

Max's Christmas Dinner. Laura and Tommy Dean, the owners of Max's, threw a Christmas party in 1975, giving free dinner to all the musicians who played there. In this photo are Wayne County, the Ramones, members of the Dolls, Miamis, the Fast, Blondie, Robert Gordon, Richard Hell, Sable Starr, and more.

Heartbreakers, NYC, 1975.
With Johnny Thunders and Jerry Nolan out of the New York Dolls and Richard Hell out of Television, the three joined together to form the Heartbreakers. It only lasted a few weeks because Johnny and Richard both wanted to be the leader. This was their first photo session. The fire escape was outside the Dolls' rehearsal space on West 23rd.

Pinball, CBGB, 1977.
David Johansen, Dee Dee Ramone, and Andy Paley watch Lenny Kaye play during an often heated four-way pinball game at CBGB. The pinball machine was just inside the door past the phone booth and was very popular.

Ramones on Subway, 1977. I was making a story on the Ramones for *Rock Scene* magazine. I met them in Forest Hills and after some shots in their neighborhood we took the subway to their show that night at CBGB. They couldn't even afford guitar cases. Johnny said they wrote their own songs because they weren't good enough to play anyone else's.

ebet roberts

having grown up in memphis and before that around europe i moved to
new york in the seventies to continue a career in painting

for awhile i had been slowly moving from painting to integrating
 photography into painting to working with photography as an end

music had always had a strong influence on my paintings i had a lot of friends who played music

a friend asked me to take some photographs of his friend binkys band the planets i ran into willie deville
and his wife toots and wanted to photograph them which led to cbgb there was too much to photograph
the people the bands the club i photographed there nightly the same bands sometimes played at different clubs and i went there too and then there were many bands from england coming over to play the bands and the music and the audience kept spreading wider

i took a long detour from painting resulting in these and many more photographs

joe strummer from the clash at the palladium in new york city
march 7 1980 at the end of the show a fan threw roses on the
stage and i noticed him leaning over to pick one up

willie deville from mink deville with toots at maxs kansas city january 1977 willie had asked me to take some photographs of the band after the show willie was hanging out backstage with his wife toots and i photographed them

johnny rotten at the talieson
ballroom in memphis tennessee
january 16 1978

iggy pop at the palladium in new york city october 6 1977 iggy and the stooges were worshiped by the punks

sid vicious at the talieson ballroom in memphis tennessee january 6 1978 the band was creating a lot of excitement in the press and seemed to make headline news everywhere they played the floor was moving up and down *with* the crowd and i was sure it was going to collapse any minute the edginess of not knowing what might happen next on stage just added to the exciting and crazy energy that filled the room

the cars in new york city july 17 1978 as i was photographing the cars in front of the gramercy park hotel a female jogger ran by and i hoped she was in the frame the cars had just begun their first tour

helene ross at cbgb
july 22 1977 i pho-
tographed helene in
the ladies room at
cbgb the dead boys
were playing that
night she was was
a friend of stiv bator
and spent a lot of
time at cbgb

stiv bators and cheetah chrome at a dead boys show at cbgb april 1977 they were always fun and crazy at the end of the show stiv ended up knocking the drums all over the stage

sex pistols fan at the tallieson ballroom in memphis
tennessee january 6 1978 the show was over and i was
leaving when i noticed him still sitting there screaming

alan vega and marty rev from suicide in new york
city january 20 1980 this photograph was
taken for rolling stone at alans loft

(left) bette bright from
deaf school at cbgb june
18 1977 deaf school
was a band from liverpool
that included cliff langer
on guitar who has since
produced innumerable
bands including elvis
costello madness teardrop
explodes morrisey and
bush

(opposite) elvis costello
at the capitol theater in
passaic new jersey may 5
1978 the bill included
mink deville and rockpile
with dave edmunds and
nick lowe. this photograph
appeared on the cover of
the village voice

tom verlaine from television at the
bottom line june 11 1978

snooky from sic fucks at cbgb march 11 1978 snooky and her sister tish who was also in sic fucks owned a punk clothing store on st marks called manic panic

the jam at cbgb october 15 1977 it was their first tour to the states and i photographed them for the village voice in the dressing room before they played

mark mothersbaugh or boogie boy from devo at nathans on forty second street july 9 1977 i was photographing devo and we went into nathans to get something to drink photographing mark as boogie boy was always strange because he would assume a new persona and become boogie boy

nico at cbgb february 19 1979 nico was playing harmonium and john cale viola half the musicians in new york were at cbgb that night

dave vanian from the damned at cbgb april 1977 cbgb had huge posters on the side wall of the stage the band threw a couple of dozen cream pies at the audience i was very happy to miss the initial onslaught but hadn't taken into account that everyone covered with pie would sling it around the room so by the end of the show i was drenched in sticky pie as was my camera

patti smith in asbury park new jersey august 5 1978 the ramones were on the same show

annie golden from the shirts at cbgb june 19 1979 annie also had an
acting career and was featured in the the movie hair

poly styrene from x-ray spex at cbgb march 25 1978 she had a wonderful metal
lunchbox that said schoolbus that she used for her purse

about the
photographers

roberta bayley

As chief photographer for the legendary *Punk* magazine, Roberta Bayley began photographing the soon-to-be-famous progenitors of punk in 1975, amassing perhaps the earliest complete document of the New York punk scene's formative days. She shot album covers for the Ramones, Richard Hell, and Johnny Thunders's Heartbreakers and recorded the British punk invasion, including the Sex Pistols, the Clash, the Damned, Elvis Costello, Billy Idol, and X-Ray Spex. In 1991 *Rolling Stone* magazine selected Bayley's cover shot for the Ramones' first album as one of 100 Best Album covers of the rock era.

Bayley's photographs have appeared in magazines, books, and newspapers throughout the world. Her recent CD artwork includes *Blondie, the Platinum Collection* (Chrysalis Records, 1995), *David Johansen* (Rhino Records, 1995), *Ramones: All the Stuff (and More) Vols. 1—3* (Sire/Warner Bros., 1990), *Dave Edmunds Anthology* (Rhino, 1993), and several volumes of Rhino Records *DIY* series, released in 1993.

Solo exhibitions include the Bad and the Beautiful, Deer Gallery, New York, 1993, and Roberta Bayley, Peppermint Lounge, New York, 1983. Group shows include Blank Generation Revisited, CB's 313 Gallery, New York, 1991; the Melkweg, Amsterdam, 1994; Lubbock or Leave It, Austin, Texas, 1995; Art After Midnight, the Palladium, New York, 1986; New Wave, New York, P.S.1, Long Island City, New York, 1981; and the Punk Art Show, Washington, DC, Project for the Arts, 1978. In 1996 Bayley curated the definitive punk photo exhibit, The Cool & the Crazy, at the Candace Perich Gallery in Connecticut, the Earl McGrath Gallery in New York City, and Govinda Gallery in Washington, DC.

Roberta Bayley, right, with Debbie Harry. Photo ©Bobby Grossman

stephanie chernikowski

Shortly after moving to Manhattan from her native Texas in 1975, Stephanie Chernikowski began photographing the downtown music scene and its artists, aided and abetted by frequent assignments from *The Village Voice*, *Rolling Stone*, the *New York Times*, and other publications, and by her landlord Andy Warhol, who was kind enough not to evict her when she bought film with her rent money. Her images have since been published in books and periodicals around the world, as well as appearing on albums, t-shirts, posters, and postcards, and have been commissioned by artists, writers, and record companies, including R.E.M., Henry Rollins, Richard Hell, Daniel Lanois, Alex Chilton, Willie Nelson, Stevie Ray Vaughn, Eric Ambel, Les Blank, the Cramps, and the dB's. She is also a published writer.

Exhibitions include Blank Generation Revisited at CB's 313 Gallery in New York; Stichting Melkweg in Amsterdam; Lubbock or Leave It, Austin, Texas; The Cool & the Crazy at Candace Perich Gallery, Ridgefield, Connecticut; the Earl McGrath Gallery in New York City; Govinda Gallery in Washington, DC; Man and Peace: Third International Exhibition, USSR (traveling); The Village Voice Group Show, Overseas Press Club, New York City; and a solo show, Late Night Reruns and Coming Attractions, Congo Bill/Danceteria, NYC. A book of her Punk/New Wave photos entitled *Dream Baby Dream* was published in the spring of 1996 by Henry Rollins's 2.13.61 Publications.

george du bose

Originally apprenticed to commercial and fashion photographers, George Du Bose first became associated with New Wave music after he began speculative work with the fledgling B-52's from Athens, Georgia. He has photographed and designed over 200 album covers, collecting eighteen gold and platinum albums for groups as diverse as the Go-Gos, Melissa Etheridge, Kid Creole and the Coconuts, Biz Markie, and Big Daddy Kane. The Ramones have commissioned him to photograph or design their last nine covers; it is their only gold record for *Ramonesmania* that he most treasures. He continues to provide creative guidance, art direction, computer graphic design, photography, and manufacturing assistance for major record companies and up-and-coming artists who want to produce their own albums.

Du Bose's professional experience includes staff positions as art director and photographer for Island Records and Cold Chillin Records, the first photo editor for *SPIN* magazine and the Image Bank, and staff photographer for the original *Interview* magazine. His company, Pop Eye Design America, lists Island Trading Company, the New Music Seminar, PolyGram, Warner Bros., Sony, and MCA among its clients.

godlis

Godlis began photographing at CBGB's in 1976. As a refugee of the New York City street photography scene, his work reveals an infatuation with Leica cameras, long handheld exposures, and Brassai's classic night photographs of Paris in the 1930s. His grainy black and white images document the NYC punk scene of the '70s under the Bowery streetlights. His work has appeared in numerous books, newspapers, magazines, and CD booklets.

Solo exhibitions include In God We Trust, Deer Gallery, New York, 1993; Jack Kerouac's Lowell, Arles Recontres, France, 1991; Rock et Photo, Arles Recontres, France, 1986; Town Without Pity, Grossmont College, California, 1981; Sights for Sore Eyes, Eleventh Street Gallery, NYC, 1981.

Group exhibitions include The Cool & the Crazy at Earl McGrath Gallery, NYC, 1996, Candace Perich Gallery, Connecticut, Govinda Gallery, Washington, DC; Photographie sur L'Humor, Montpelier, France, 1993; Blank Generation Revisited at CB's 313 Gallery, NYC, 1991, Amsterdam, 1994, Austin, Texas, 1995; On the Edge, Henry St. Settlement, NYC, 1991; 57th & Fifth, Pace MacGill Gallery, NYC, 1987; Art After Midnight, The Palladium, New York, 1986; The Lower East Side, City Gallery/Henry St. Settlement, NYC, 1984; New Wave/New York, P.S. 1, Long Island City, New York, 1981; Miami Beach Photographs, Imageworks Gallery, Cambridge, Massachusetts, 1974.

bob gruen

Bob Gruen grew up on Long Island, New York, and started snapping pictures on a Brownie Hawkeye. He began photographing bands professionally even before there was such a thing as "rock" photographers. Today his work is known around the world.

Gruen has been on the road with nearly every major rock attraction, including Elton John, Alice Cooper, Led Zeppelin, the Rolling Stones, Tina Turner, and many others. For years he was the official photographer of the New Music Seminar, covering dozens of aspiring groups in the course of a summer week. In 1989 he documented a group of heavy metal bands making an epic journey to Russia for the Moscow Music Peace Festival.

Bob was the chief photographer for *Rock Scene*, a magazine that specialized in candid, you-are-there photo features. He toured with the leading lights of the Punk and New Wave scenes, including the NY Dolls, the Sex Pistols, the Clash, the Ramones, Blondie, the Patti Smith Group, and the B-52s. During John Lennon's stay in New York in the seventies, Bob became John and Yoko's court photographer, documenting them at work and play up to Lennon's final days. A limited edition book, *Sometime in New York City* (Genesis Publications, 1995), tells this tale through Bob's photographs and stories, and the words of John and Yoko. It is the crown jewel of his many books.

He has had numerous exhibitions of his historic journey, most notably the Govinda Gallery in Washington, DC, in 1995 and Special Photographers Company in London in 1995; Ron Wood's Gallery in New York, 1990; Sex & Rock & Roll at the Susan Cooper Gallery in Woodstock, New York, 1991; The Cool & the Crazy, Candace Perich Gallery, Ridgefield, Connecticut, and the Earl McGrath Gallery in New York City, 1996.

Bob Gruen enjoys a sip between snaps with Sid Vicious in Oklahoma City during the Sex Pistols U.S. tour, 1978. Photo: Roberta Bayley

ebet roberts

Ebet Roberts moved from her native Memphis to New York to paint but switched to photography in 1977 when she began documenting the evolving CBGB scene. Inside the music business she is recognized as the consummate pro who has photographed everyone. Roberts's photography has been reproduced as album and book covers, press shots, and posters for such rock, classical, and jazz musicians as Bob Marley, Neil Young, Ravi Shankar, Phillip Glass, Bob Dylan, R.E.M., The Cure, Suzanne Vega, Robert Plant, Bruce Springsteen, Miles Davis, Talking Heads, Bon Jovi, and Michael Jackson, and in over 100 books including 1988's *This Ain't No Disco: The Story of CBGB*.

Publications include the *New York Times*, *Rolling Stone*, *Musician*, *Newsweek*, *Time*, *People*, *USA Today*, *New York*, *The Village Voice*, and *Entertainment Weekly*. Books: *Rock Stars* by Timothy White, *Frozen Fire: The Story of the Cars* by Toby Goldstein, *Written in My Soul* by Bill Flanagan, *The Rolling Stone Illustrated History of Rock 'n' Roll* by Anthony deCurtis and James Henke, and *Empty Places* by Laurie Anderson.